EXCITED

HAPPY

STRONG

CURIOUS

HA

FLIRTY

SURPRISED

GRATEFUL

CALM

CALM

PLAYFUL

STRONG

RELAXED

FIERCE

INSPIRED

CAREFREE

PUMPED

SHY

FIERCE

FEARLESS

SHY

TIRED

STRONG

POWERFUL

CURIOUS

WORRIED

BORED

MEH

CONFUSED

MEH

SAD

ANGRY

FLUSTERED

SAD

SICK

GROUCHY

SUSPICIOUS

PANICKED

BORED

ANNOYED

MAD

STRESSED

LIVID

MAD

GLUM

AFRAID

TENSE

UPSET

ANGRY

HAPPY AS A clam

GOOD AS gold

BRAVE AS A lion

SERENE AS A sloth

SWEET AS candy

HAPPY AS A clam

SWEET AS candy

HAPPY AS A clam

GOOD AS gold

BRAVE AS A lion

SERENE AS A sloth

SWEET AS candy

GOOD AS gold

BRAVE AS A lion

SERENE AS A sloth

SWEET AS candy

HAPPY AS A clam

GOOD AS gold

FREE AS A bird

TALL AS A mountain

BUSY AS A bee

COOL AS A cucumber

HUNGRY LIKE A wolf

FREE AS A bird

HUNGRY LIKE A wolf

COOL AS A cucumber

TALL AS A mountain

FREE AS A bird

BUSY AS A bee

HUNGRY LIKE A wolf

BUSY AS A bee

FREE AS A bird

COOL AS A cucumber

HUNGRY LIKE A wolf

TALL AS A mountain

COLD AS ice

COLD AS ice

SLY AS A fox

LOUD AS thunder

SAD LIKE THE willow

MAD AS A hornet

BUSY AS A bee

MAD AS A hornet

SAD LIKE THE willow

SLY AS A fox

LOUD AS thunder

SAD LIKE THE willow

COLD AS ice

LOUD AS thunder

COLD AS ice

MAD AS A hornet

SLY AS A fox

MAD AS A hornet

LOUD AS thunder

 EXCITED
 STRONG
 FIERCE
 HAPPY
 FIERCE
 EXCITED
 STRONG
 HAPPY

 HAPPY
 EXCITED
 STRONG
ALL THE FEELS
 EXCITED
 STRONG
 HAPPY
 FIERCE
 EXCITED

 FIERCE
 HAPPY
 STRONG
 FIERCE
 INSPIRED
 RELAXED
 HOPEFUL

 RELAXED
 INSPIRED
 HOPEFUL
 RELAXED
 HOPEFUL
ALL THE FEELS
 INSPIRED
 HOPEFUL

 INSPIRED
ALL THE FEELS
 RELAXED
 INSPIRED
 HOPEFUL
 INSPIRED
 BUMMED
 GROUCHY

 TIRED
 HUNGRY
 GROUCHY
 BUMMED
 TIRED
 GROUCHY
ALL THE FEELS
 HUNGRY

 BUMMED
 TIRED
 HUNGRY
 GROUCHY
ALL THE FEELS
 BUMMED
 HUNGRY
 TIRED

INSPIRED CONTENT PUMPED MEH JAZZED

BUBBLY GLEEFUL CALM PLEASED CHEERFUL

INSPIRED ECSTATIC PUMPED LUCKY LOVELY

THRILLED ICKY FIERCE ECSTATIC INSPIRED

YIKES FIERCE WONDERFUL CHEERY HAPPY

SERENE PLEASED MEH EMBARRASSED YIKES

YIKES CALM RELIEVED ASTONISHED PLEASED

CALM RELIEVED MEH EMBARRASSED RELIEVED

HURT AFRAID QUEASY DISMAYED GLOOMY

TENSE ANXIOUS WORRIED UPSET ANXIOUS

NOPE PEEVED TROUBLED INCENSED NOPE

UPSET FURIOUS CRANKY AFRAID CRABBY

SO SO SO happy.

RELIEVED

PLAYFUL

Happy as a clam.

Curious.

BEAUTIFUL

POWERFUL

Perfectly imperfect.

EMBARRASSED

Inspired.

Feeling loved.

Sweet like candy.

Busy as a bee.

Serene as a sloth.

GRATEFUL

CAREFREE

Wise as an owl.

SURPRISED

FLUSTERED

Loud as thunder.

Deep like the ocean.

STRESSED

TIRED

Curious as a cat.

Sly as a fox.

SUSPICIOUS

All the feels.

Under the weather.

Rainy day mood.

BORED

Sending good vibes.

PANICKED

Today is gray.

So many feelings.

ANNOYED

Feeling weighed down.

Down in the dumps.

Feeling blue.

WORRIED

AFRAID

Feeling stormy.

BEAUTIFUL

FEELING
UNSTOPPABLE

TIRED

DISAPPOINTED

ANNOYED

HAPPY CHEEKY GRATEFUL ❀ RELAXED ❀

RELAXED ❀ BEAUTIFUL GRATEFUL ❀ RAD

GRATEFUL HAPPY ❀ BEAUTIFUL RELAXED

UNSTOPPABLE GRATEFUL CHEEKY ❀ HAPPY

❀ CURIOUS BORED TIRED ❀ SATISFIED

SAD ❀ TIRED CURIOUS SATISFIED DONE

❀ CURIOUS BORED ❀ DONE SATISFIED

STRESSED ANGRY EXHAUSTED ❀ ANNOYED

GRUMPY ❀ LIVID ANNOYED ❀ OVER IT

OVER IT ANNOYED ❀ STRESSED ANGRY ❀

sun and fun

dreaming in color

over the moon

on cloud nine

soul full of sunshine

soul full of sunshine

over the moon

on cloud nine

dreaming in color

sun and fun

sun and fun

dreaming in color

over the moon

on cloud nine

soul full of sunshine

soul full of sunshine

over the moon

on cloud nine

dreaming in color

sun and fun

calm before the storm

don't rain on my parade

no rain no rainbow

in hot water

the sky's the limit

no rain no rainbow

the sky's the limit

in hot water

don't rain on my parade

calm before the storm

calm before the storm

don't rain on my parade

no rain no rainbow

the sky's the limit

in hot water

under the weather

on thin ice

the perfect storm

blowing off steam

feeling stormy

feeling stormy

blowing off steam

on thin ice

the perfect storm

under the weather

under the weather

on thin ice

the perfect storm

blowing off steam

feeling stormy

 HAPPY
 CALM
 EXCITED
 FLIRTY
 RELAXED
 HAPPY
 CALM

 FLIRTY
 RELAXED
 HAPPY
 CALM
 EXCITED
 FLIRTY
 RELAXED

 CALM
 EXCITED
 FLIRTY
 RELAXED
 HAPPY
 CALM
 EXCITED

 SURPRISED
 BORED
 TIRED
 CONFUSED
 MEH
 SURPRISED
 BORED

 CONFUSED
 MEH
 SURPRISED
 BORED
 TIRED
 CONFUSED
 MEH

 TIRED
 CONFUSED
 MEH
 SURPRISED
 BORED
 TIRED
 CONFUSED

 GRUMPY
 SAD
 ANGRY
 WORRIED
 STRESSED
 GRUMPY
 SAD

 WORRIED
 STRESSED
 SAD
 ANGRY
 WORRIED
 STRESSED
 GRUMPY

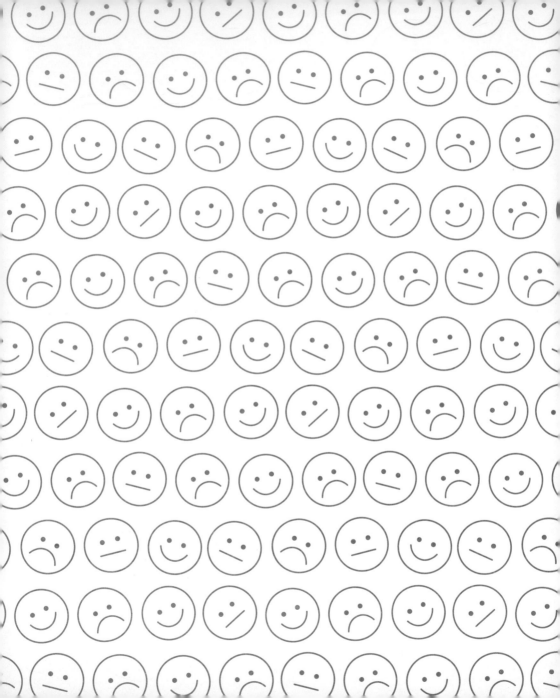

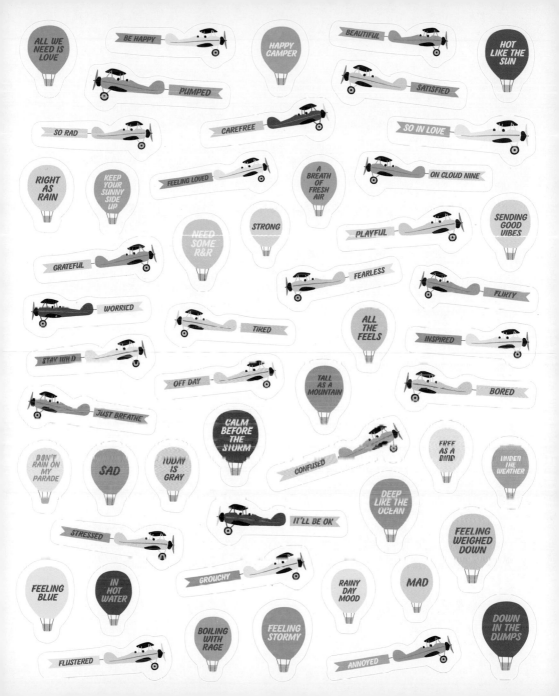

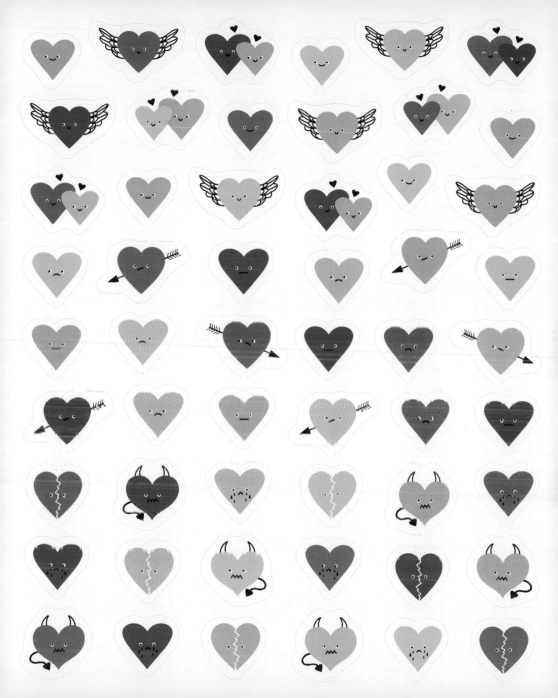

HAPPY ★ EXCITED WONDERFUL ☮ CHILLED OUT

CHILLED OUT HAPPY EXCITED WONDERFUL GRATEFUL

GRATEFUL ★ CHILLED OUT ♡ HAPPY EXCITED

THRILLED CONTENT UNSURE ☮ TIRED SCARED

SCARED ☮ THRILLED ♡ CONTENT UNSURE

UNSURE ★ TIRED ★ THRILLED ♡ CONTENT

ANGRY STRESSED SAD GROUCHY AFRAID

AFRAID ☮ SAD ★ GROUCHY ♡ ANGRY

STRESSED GROUCHY ☮ ANGRY UPSET SAD

SAD ★ UPSET STRESSED AFRAID GROUCHY

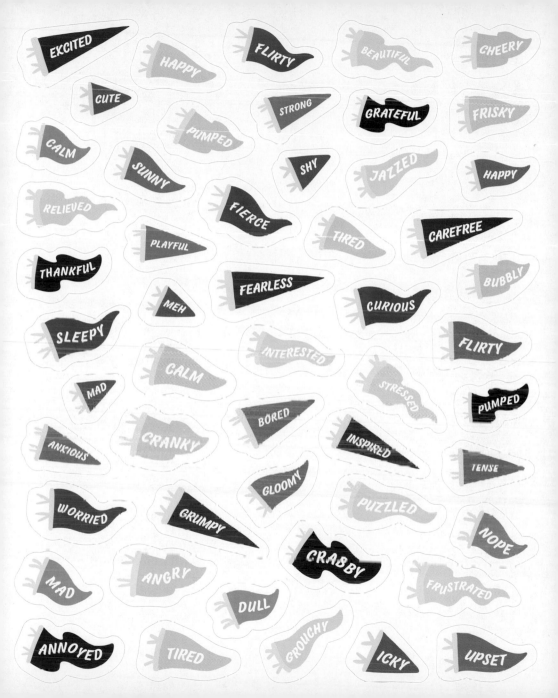

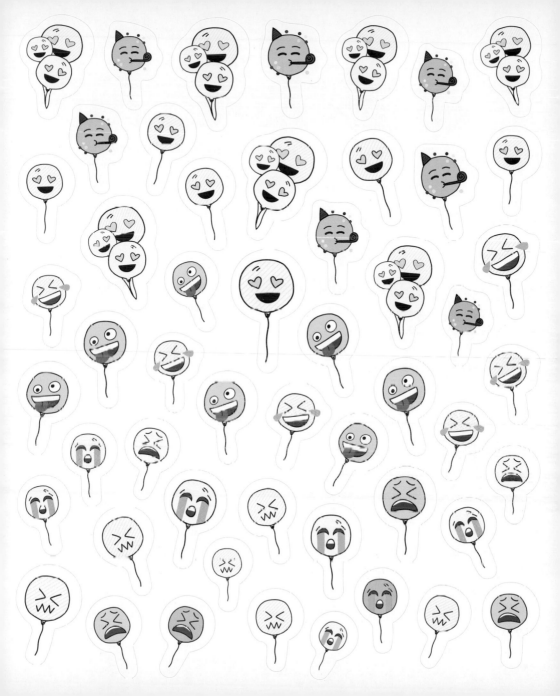

Time to PARTY!

Merry & BRIGHT

Yay for HOLIDAYS!

Feeling FESTIVE

A Day To CELEBRATE

Feeling FESTIVE

A Day To CELEBRATE

Merry & BRIGHT

Yay for HOLIDAYS!

Time to PARTY!

Time to PARTY!

Merry & BRIGHT

Yay for HOLIDAYS!

Feeling FESTIVE

A Day To CELEBRATE

Up to SNOW GOOD

Many THANKS

Creepin' IT REAL

Thankful FOR...

Feast MODE

Many THANKS

Thankful FOR...

Feast MODE

Up to SNOW GOOD

Creepin' IT REAL

Up to SNOW GOOD

Many THANKS

Creepin' IT REAL

Feast MODE

Thankful FOR...

BE Witched

Resting GRINCH FACE

Not in a JOLLY MOOD

Party POOPER

Not in a JOLLY MOOD

Party POOPER

Resting GRINCH FACE

BE Witched

BE Witched

Resting GRINCH FACE

Not in a JOLLY MOOD

Party POOPER

Be Happy

BEAUTIFUL

Wide Awake

FEELING LOVED

SUNNY

CUTE

PROUD

THRILLED

PLAYFUL

PUMPED

EXCITED

SUNNY

LUCKY

INSPIRED

No Worries

KEEP CALM

DULL

relieved

SERENE

FLIRTY

EASY PEASY

STRONG

CURIOUS

SLEEPY

SHY

BLISSFUL

MEH

SHAKEN

at a LOSS

DAZED

OFF DAY

DON'T CARE

ON EDGE

STRESSED

TENSE

BURNT OUT

GRUMPY

WORN OUT

ICKY

LIVID

GLOOMY

FED UP

OUT OF SORTS

IRATE

AFRAID

GLUM

HURT

ANGRY

ALL WORKED UP

CRANKY

MAD

ANNOYED

happy excited **wonderful** grateful relaxed

relaxed grateful excited beautiful happy

grateful beautiful relaxed sunny excited

sunny **excited** wonderful grateful relaxed

satisfied scared weary bored curious

scared tired **curious** satisfied dull

fulfilled scared tired bored **curious**

curious dull scared weary fulfilled

irked worn out annoyed sad cranky

grumpy sad angry stressed annoyed

sad annoyed worn out cranky irked

angry stressed annoyed sad grumpy

thrilled ecstatic over the moon happy thrilled

happy ecstatic thrilled over the moon happy

ecstatic over the moon happy thrilled ecstatic

thrilled happy over the moon ecstatic thrilled

eager confused tired lonely impatient

impatient tired eager confused lonely

eager confused tired lonely impatient

impatient tired lonely eager confused

depressed feeling all the feels upset furious

disappointed upset furious feeling all the feels

feeling all the feels depressed upset furious

disappointed furious feeling all the feels upset

ecstatic	pumped	fierce	pleased	inspired
pleased	inspired	ecstatic	pumped	fierce
fierce	pleased	inspired	ecstatic	pumped
pleased	inspired	ecstatic	pumped	fierce

calm	relieved	meh	embarrassed	sick
yikes	meh	calm	embarrassed	relieved
relieved	embarrassed	yikes	sick	calm
relieved	embarrassed	yikes	calm	meh

upset	anxious	worried	afraid	nope	mad
anxious	mad	nope	anxious	upset	afraid
afraid	worried	upset	mad	anxious	nope